THE HEADLESS BUST

A Melancholy Meditation on the False Millennium

EDWARD GOREY

HARCOURT BRACE & COMPANY
New York San Diego London

Requests for permission to make copies of any part of the work should
be mailed to the following address: Permissions Department, Harcourt, Inc.,
6277 Sea Harbor Drive, Orlando, Florida 32887-6777.

Library of Congress Cataloging-in-Publication Data
Gorey, Edward. 1925–
The headless bust: a melancholy meditation on the
false millennium/Edward Gorey.
p. cm.
ISBN 0-15-100514-1
1. Millennium Poetry. I. Title.
PS3557.O753H43 1999
811'.54—dc21 99-29870

Printed in the United States of America
First edition
ACEDB

To the memory of Lancelot Brown

'Twas hours and hours after dawn
Ere the last guest was fin'lly gone.
Ça va, hélas, from bad to worse:
Adieu to prose, allô to verse.

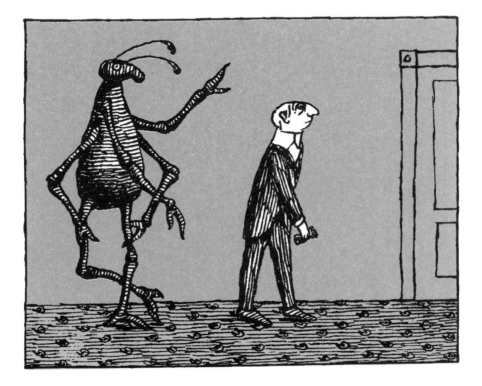

The Bahhumbug with lack of tact
Now called attention to the fact,
Which made it feel to Edmund Gravel
He was already to unravel.

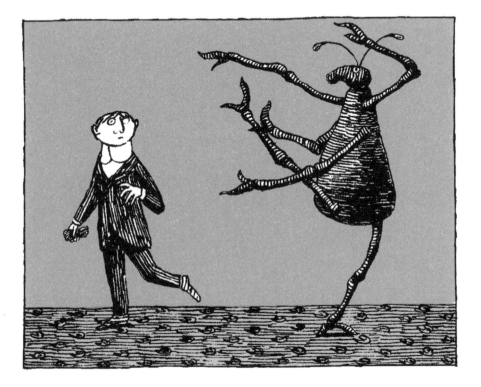

While Edmund dozed, the Bahhumbug
Was picking crumbs from off the rug;
A noise disturbed the morning gloom
And something flapped around the room.

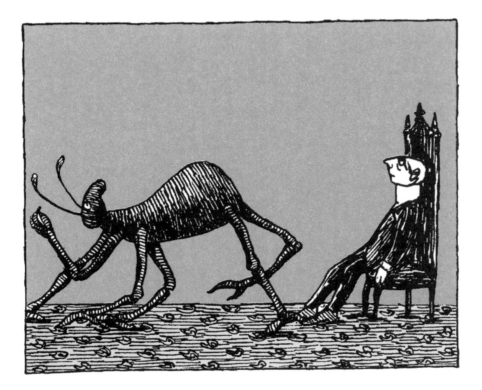

In tinny tones it whispered, 'I'm
Arrived, and only just in time
To take you both from place to place
Where there is shame, also disgrace.'

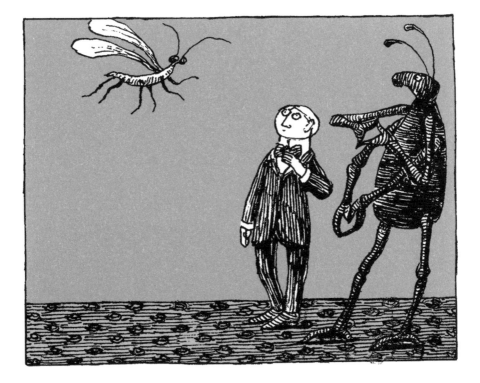

They felt themselves wound up in shrouds —
Or were they only woolly clouds?
Till shortly after they came down
In some remote provincial town.

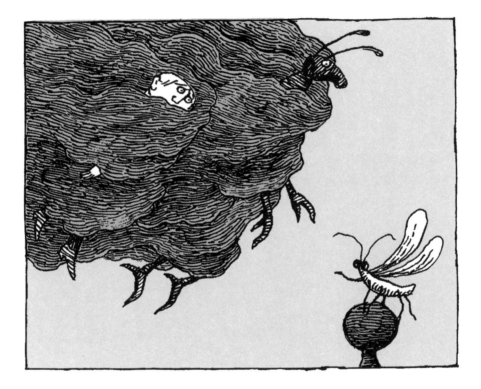

'Initial, dash *cannot conceal*
The fact that everything is real,
But whether it is also true
Is left entirely up to you.'

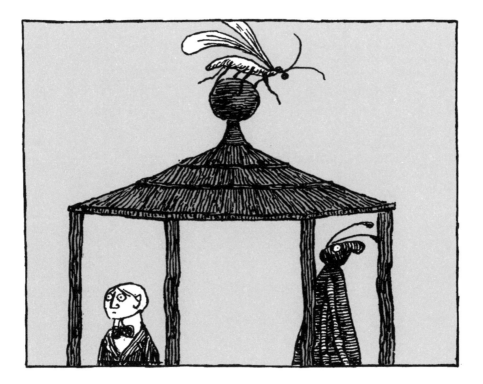

The famous essay writer, V——
Was one for strict propriety,
So few were privileged to know
His left foot had an extra toe.

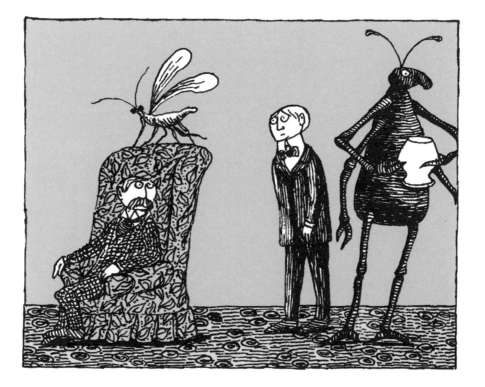

La K ___ , with waving scarves and veils,
And screams and moans and shrieks and wails,
Caused all the others at croquet
To send their balls and wits astray.

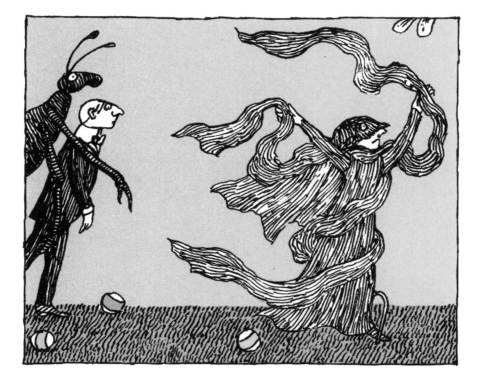

Sir U___ fell from a speeding train,
Which did some damage to his brain,
And after that he did not know
How to pronounce the letter O.

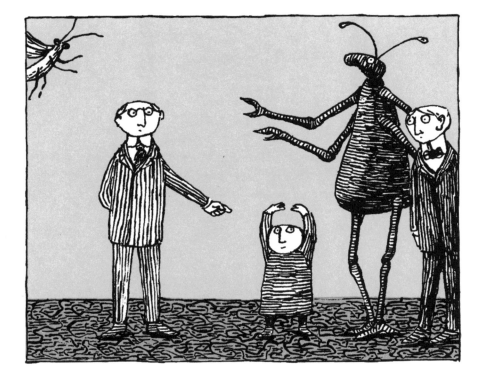

When asked if she would like an ice
She said pineapple might be nice ;
They went to buy her one, but then
Miss M ___ was never seen again.

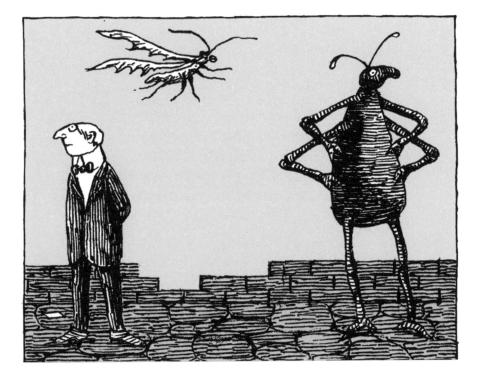

One afternoon there was a spillage
Of soothing syrup in the village
Of Godly Wot, whose dogs though shaken,
Could not at once be made to waken.

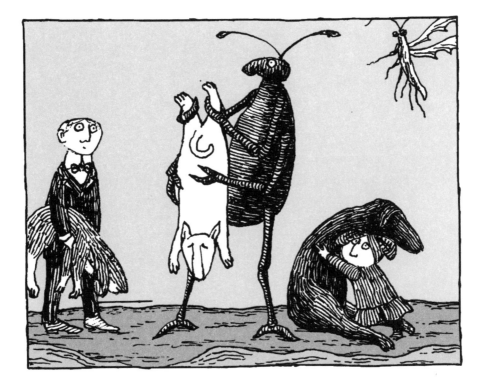

A certain R ___ , in the beau monde
Had none with whom to correspond,
And so she slyly retrieved letters
No longer wanted by her betters.

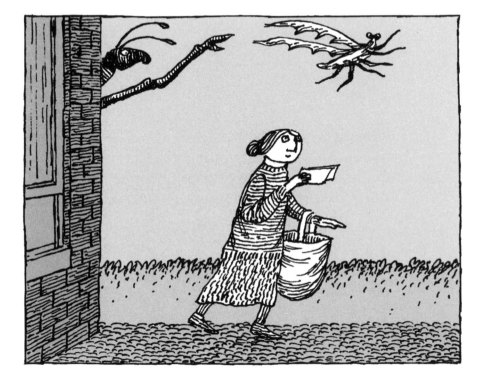

Reversing at a tango tea
In Snogg's Casino-not-on-Sea
L—— tripped and cried, 'I am afraid
They tampered with the marmalade.'

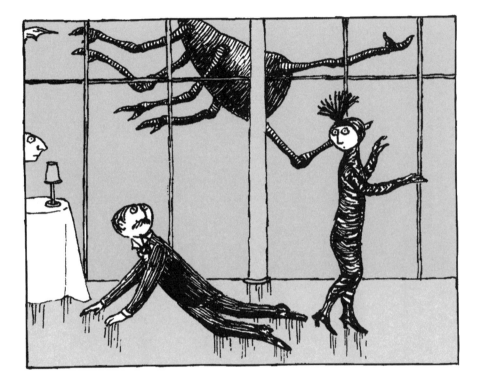

To save her lover Lady Y___
Was asked to come and testify;
She looked so dreadfully unkempt
The court soon found her in contempt.

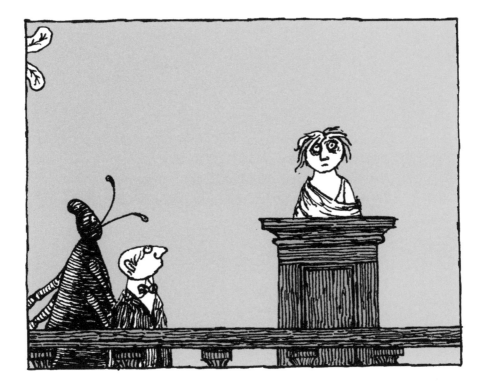

A Monument to the Unknown
Loomed up as if it had been blown
Despite its awful size and weight
There by some absent-minded Fate.

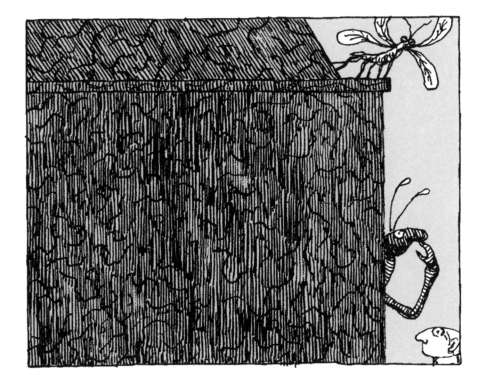

They wandered off into the fog
And nearly fell in Glummish Bog,
Which made them think to their dismay
At first of change and then decay.

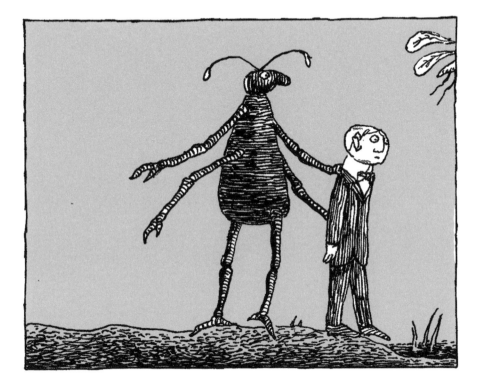

'To us it's very far from clear
The reasons for our being here.'
'We'd leave at once, but do not know
We've any place where we might go.'

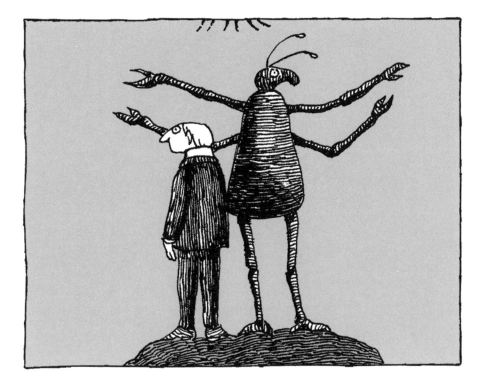

Miss N ____ saw that a greenish ooze
Had dripped upon her rhinestone shoes,
And so she could not, after all,
Attend the Bandage Folders' Ball.

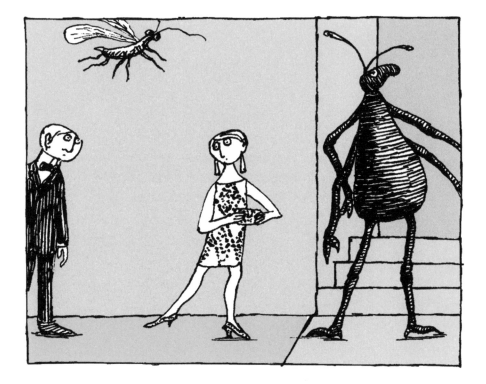

The private rooms of Monsieur H____
Were known for being oh so posh;
Then it was learned that all his druthers
Were still the property of others.

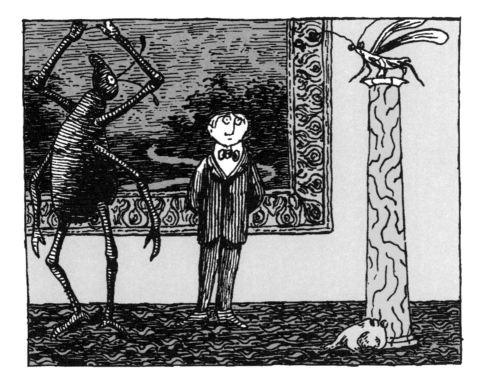

When the piano lid fell down
It ripped the back from off her gown;
The diva in a tearing rage
Forever left the concert stage.

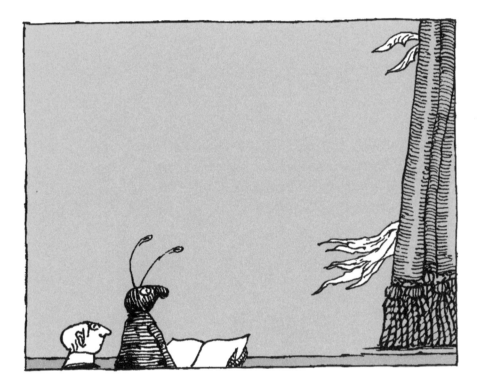

Then high above the rural scene
Appeared a giant aubergine
On which were limned for all to see
The mystic letters Q.R.V.

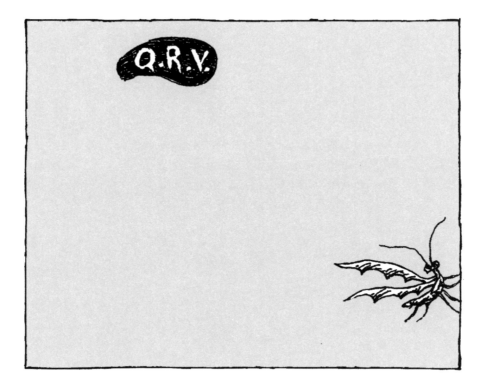

ff _____'s crocheted gloves and knitted socks
Were found on Stranglegurgle Rocks;
The doubtful circumstances led
His relatives to think him dead.

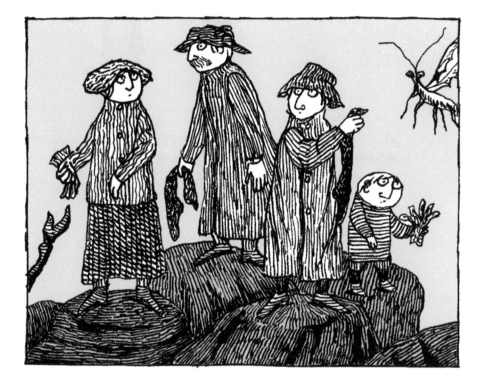

It almost drove her husband wild
When S ___ maintained their youngest child
Had been delivered by mistake
Atop a Summer Solstice Cake.

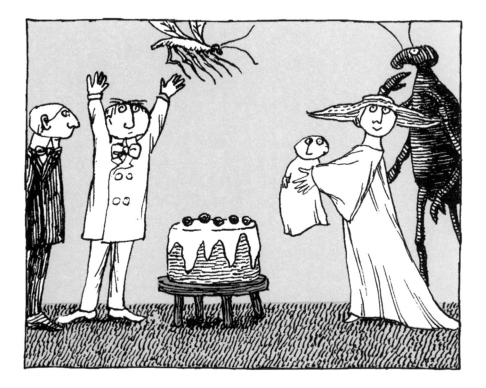

In Wiggly Blot a certain X ——,
Who looked to be of neither sex,
Was charged with gross indecency
Which everyone could plainly see.

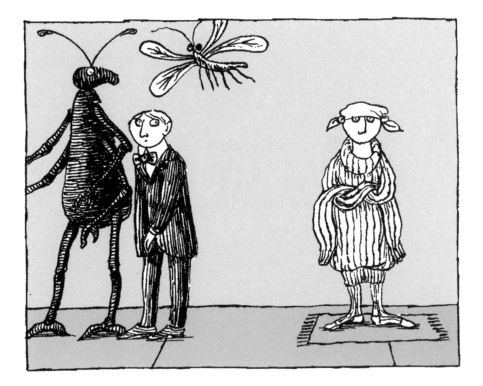

'Is it not' murmured Q —— 'quite rash
To throw that box into the trash?
Who knows we shall not find a use
For all those teeth, however loose?

The Bahhumbug said, 'Much ado…
What does it matter if they're true?'
The Whatsit hissed, dissolved in air,
And was no longer anywhere.

The Bahhumbug and Edmund Gravel
Were back from their phantasmal travel,
And so it was they had to face
The task of clearing up the place.

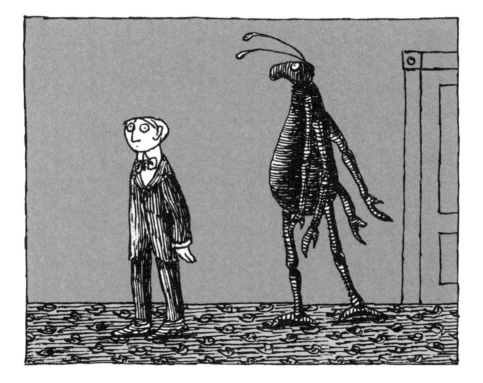

'Who were those people? Why did they
Appear to us along the way?'
'But then again, why should we care?
It's quelque chose d'un grand mystère.'

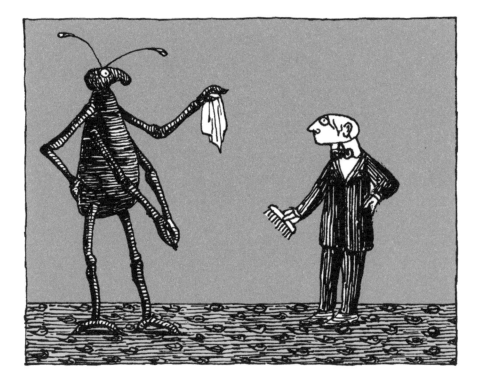

Fruitcake was sawed in blocks and sent
To Havens for the Indigent,
Where it was used for scouring floors
And propping open banging doors.

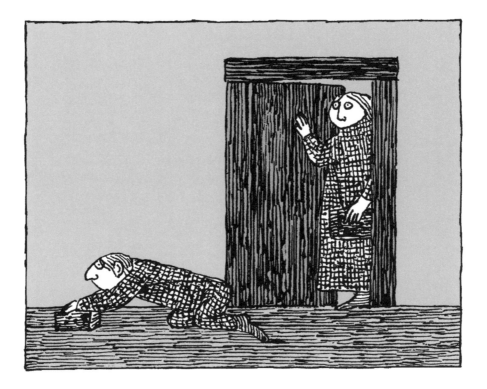

They saw it was about to come:
The end of the millennium,
So find themselves perforce to be
Into another century.

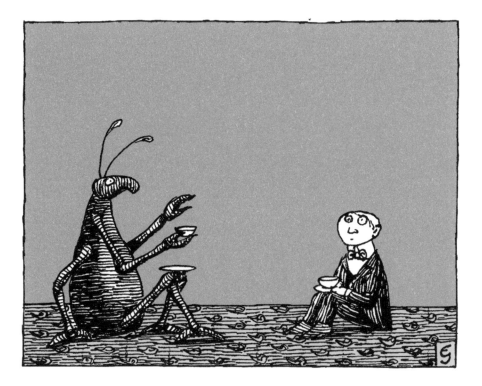